NEW ZEALAND

— a postcard tour —

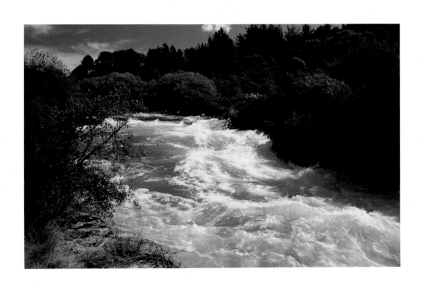

PHOTOGRAPHY BY BOB McCREE • TEXT BY BRIAN O'FLAHERTY

REED

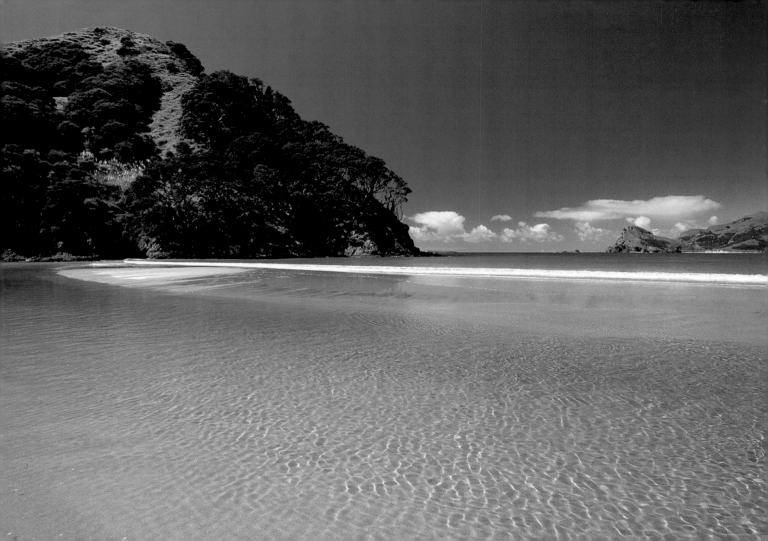

Introduction

Into its small landmass, New Zealand packs in plenty of magical and distinctive sights and stunning scenery to provide the material for endless postcards. It is a land of sharp contrasts and natural beauty presented in an amazing variety of forms: alps and glaciers or subtropical waters lapping sandy beaches, the tranquil waterways of fiords or wild wave-lashed shores, untouched rainforests or rolling pastureland.

New Zealand: A Postcard Tour provides a brief visual journey, from north to south, through the country's diverse regions, towns and cities.

Geologically, New Zealand is a relatively new land, arising on the edge of the supercontinent of Gondwanaland between 600 and 300 million years ago, then breaking away and set adrift, by the process of seafloor spreading, out into the Pacific Ocean. The journey halted some 60 million years ago, leaving New Zealand as a group of islands, one of the most isolated places of its size in the world.

The processes that formed the country continue to shape it today, resulting in some of its most dramatic features. Plate collision continues to push up the northern ranges and Southern Alps as well as providing fire for the central North Island volcanoes and heat for geysers, mudpools and hot springs.

New Zealand is also young in human terms, being one of the last landmasses to be peopled, with Maori arriving in Aotearoa from eastern Polynesia around 1000 years ago. European settlement began in earnest in the early 19th century, with immigrants building towns and cities and clearing forest for farms. Today the population of four million has a bicultural base, Maori and European, and is becoming increasingly multicultural, and forging its own unique character, culture and identity.

New Zealand: A Postcard Tour pictures some of the forms and features, sights and scenes, landmarks and landscapes of this vibrant young nation.

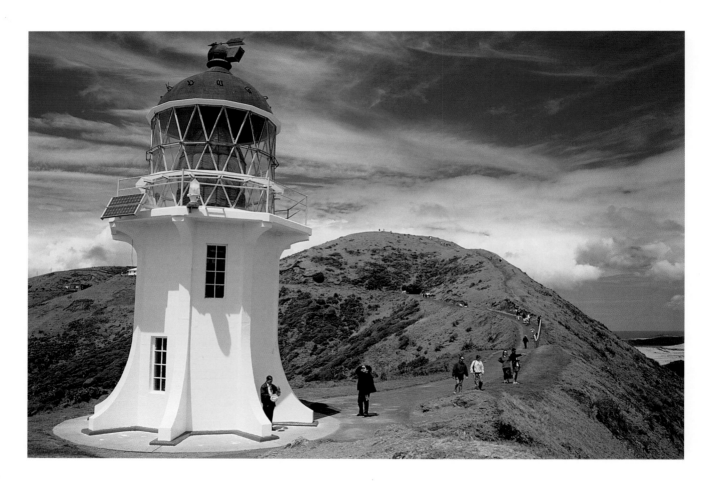

LEFT: Cape Reinga and its much-visited lighthouse lie at the northern tip of New Zealand. For Maori, Reinga is the 'place of leaping', where spirits depart for Hawaiki, the mythical homeland and place of origin of Maori.

RIGHT TOP: The Georgian-style Stone Store at the head of the Kerikeri Inlet in the Bay of Islands was built by missionaries, starting in 1832, and is the oldest stone building in the country. Today it serves as a shop and museum.

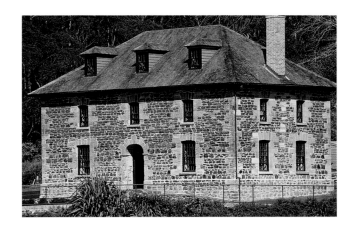

RIGHT: The Whare Runanga (meeting house) at Waitangi in the Bay of Islands, with its beautifully decorated interior, was completed in 1940 to mark the centenary of the signing of the Treaty of Waitangi. New Zealand's founding document guaranteed Maori protection of their lands, fisheries and resources but it has subsequently been interpreted by some as Maori ceding sovereignty to the British Crown, something that has been debated ever since.

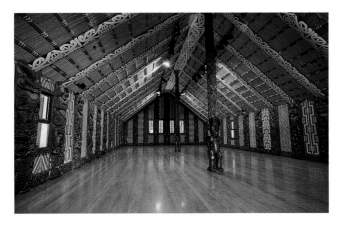

PREVIOUS PAGES: The clear water of Medland's Beach (p. 2), on rugged and scenic Great Barrier Island, the largest island in the Hauraki Gulf. The pohutukawa tree (p. 3) blossoms in early summer, making it New Zealand's Christmas tree.

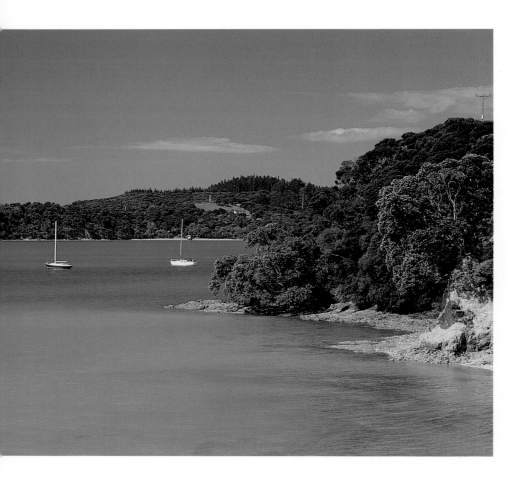

LEFT: Parekura Bay is just one of numerous secluded bays and quiet coves in the Bay of Islands. Dotted with nearly 150 islands sitting in an azure sea, the area is a magnet for summer boating activity. Sailing, game fishing, sea kayaking and diving are just some of the activities to be enjoyed.

RIGHT: On the west coast of Northland, huge sand dunes, piled up and driven by the westerly winds, mark the north head of Hokianga Harbour.

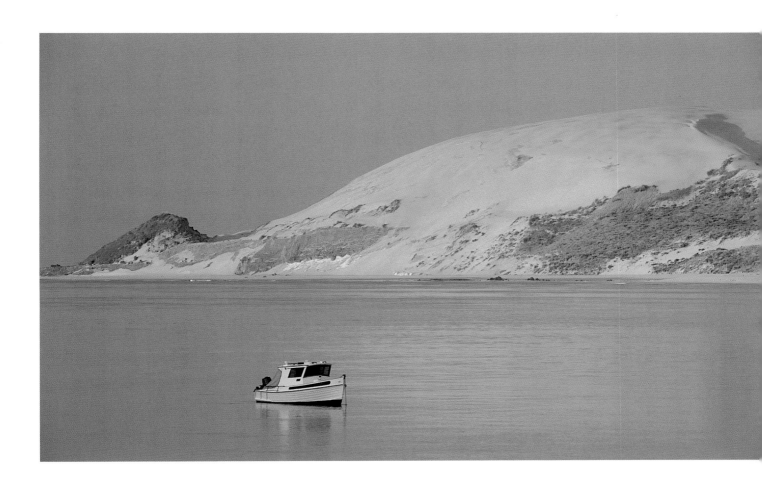

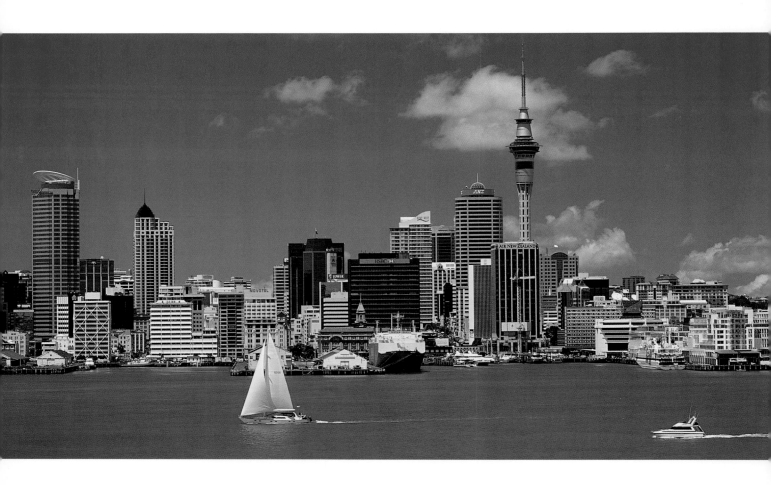

LEFT: Auckland city spreads out from its bustling commercial centre on the edge of the Waitemata Harbour. The country's largest population live in Auckland and enjoy a relaxed outdoor lifestyle.

BELOW: Westhaven is one of several marinas around Auckland's shoreline. The 'City of Sails' is almost entirely surrounded by sea, with harbours on either side of a narrow isthmus.

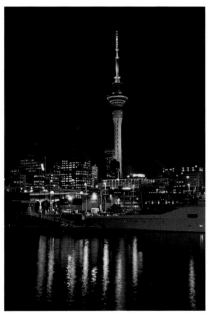

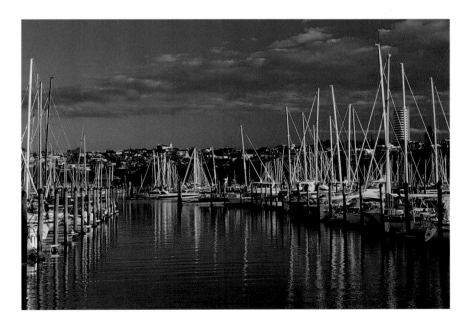

ABOVE: The Sky City Casino with its landmark Sky Tower brightens Auckland's night. At 328 metres, it is New Zealand's tallest structure, visible from a great distance. It includes an observation platform and revolving restaurant.

 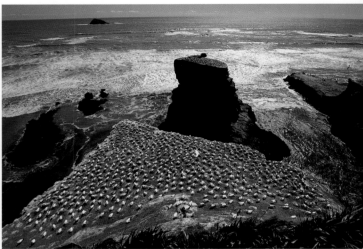

ABOVE: Aucklanders are always close to the water, with city beaches like Howick popular with swimmers and sunbathers, boaties and yachties. The city boasts one of the highest rates of boat ownership in the world as well as many world-class sailors. Annual regattas fill the harbour with thousands of yachts of all sizes.

ABOVE CENTRE: Australasian gannets are majestic seabirds with a wingspan of nearly two metres. New Zealand's most accessible colony is at Muriwai Beach on Auckland's west coast, where from July to October the birds nest on the island of Oaia, as well as on a rock stack close to shore and the mainland clifftops. Young birds depart for two to four years in Australian waters before returning to breed.

RIGHT: Lion Rock stands guard at Piha, one of the windswept and rugged beaches on Auckland's west coast, known for their black iron sands, large surf rolling in from the Tasman Sea and notorious rips.

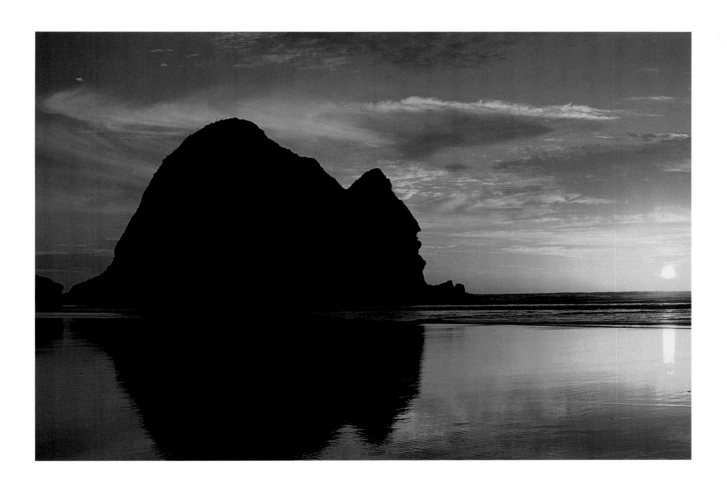

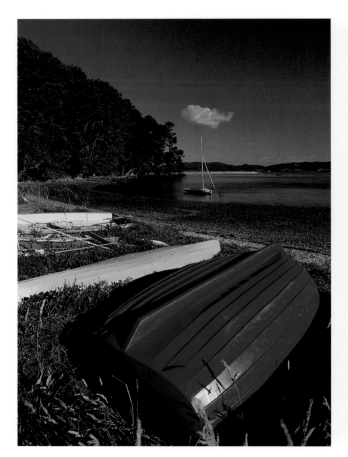

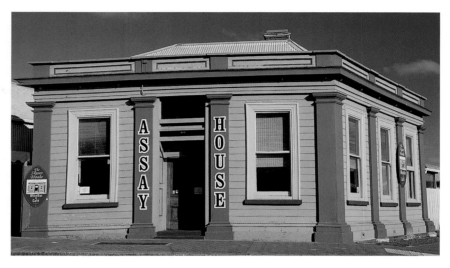

LEFT AND CENTRE: South of Auckland the sun-soaked Coromandel Peninsula has a rugged bush-clad interior and a coastline fringed with pristine white sand beaches and quiet bays, and small estuaries like Whangapoua *(left)*. Isolated Fletcher Bay *(centre)*, at the very tip of the peninsula, offers visitors deserted beaches and forest and coastal walks.

ABOVE: The Coromandel was the scene of gold rushes in the 1860s. Stamper batteries were built to crush quartz ore before extracting the gold. The Assay House in Coromandel township is one of the many relics of the era.

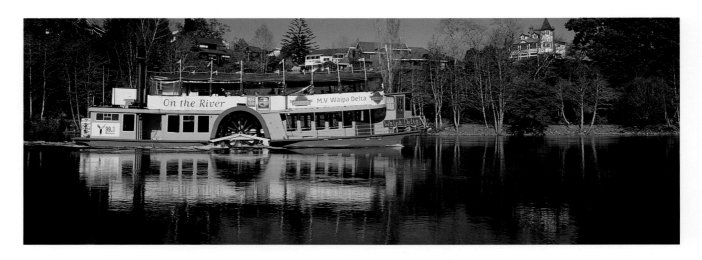

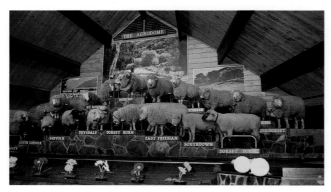

ABOVE: The *Waipa Delta* plies the Waikato River which runs through Hamilton, New Zealand's largest inland city and the heart of the biggest dairy-farming and thoroughbred district. The river, the country's longest, feeds nine hydroelectric stations before it meanders through the Waikato's plains.

LEFT: One hour's drive south of Hamilton is Rotorua, centre of a farming and forestry district and much-visited for its thermal attractions. The Agrodome farm show, demonstrating sheep breeds and the work of sheepdogs, is always popular.

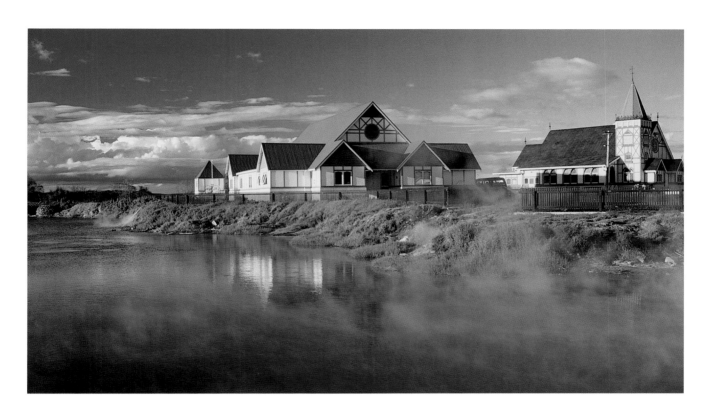

ABOVE: Steam rises from thermal springs around the Maori village of Ohinemutu on the edge of Lake Rotorua, once the base for tours to the world-famous Pink and White Terraces on Lake Rotomahana. The Anglican church of St Faiths here features a stained-glass window of Christ seemingly walking on the waters of the lake beyond.

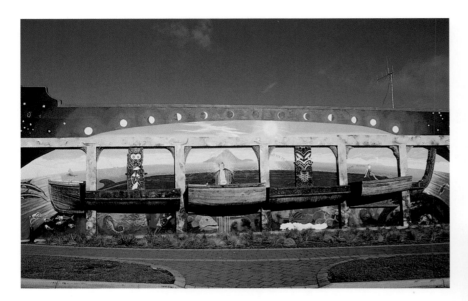

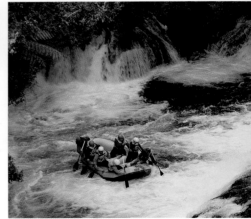

RIGHT: The 223-metre extinct dome volcano of Mauao is the ideal place to view the resort town of Mount Maunganui in the eastern Bay of Plenty, on the seaward side of Tauranga Harbour, the region's busiest port. Its white sand Main Beach is one of the country's most famous surf beaches. The area is a family holiday haven with all manner of water-based activities, from surfing and sailing to swimming with dolphins.

ABOVE: Whakatane is the main town in the eastern Bay of Plenty, a region that encompasses several offshore islands, popular beaches, and harbours and estuaries. The mural depicts the Maori migratory canoe *Mataatua* that landed at Whakatane in the 14th century.

RIGHT: Inland Bay of Plenty around Rotorua has numerous lakes and rivers, popular with anglers and outdoor adventurers, such as these whitewater rafters below Okere Falls on the Kaituna River, the outlet of Lake Rotoiti.

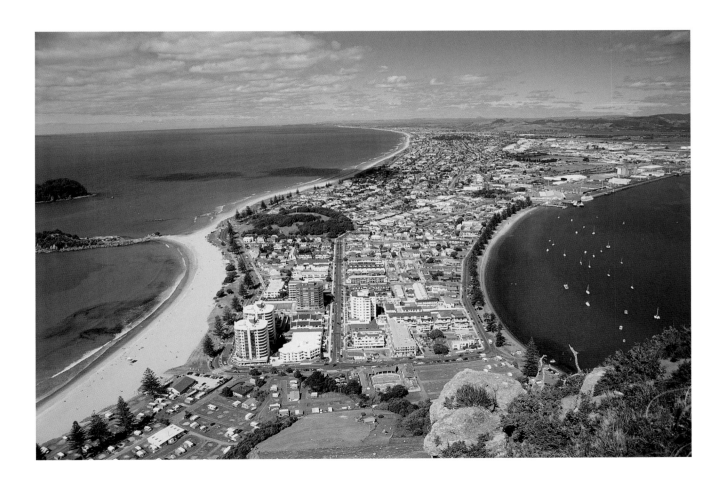

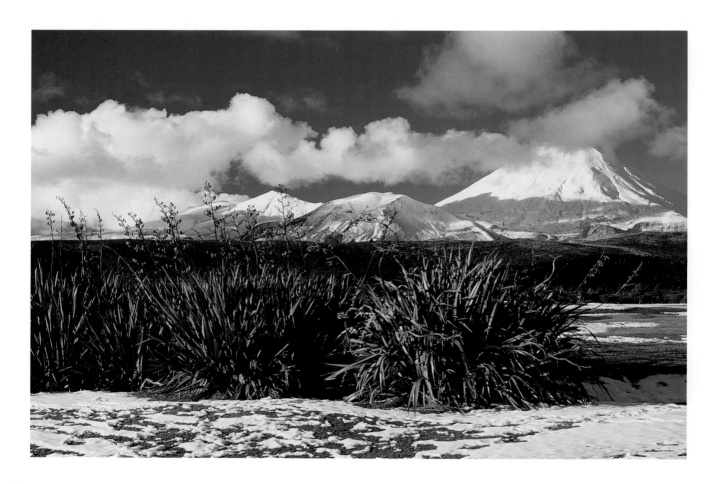

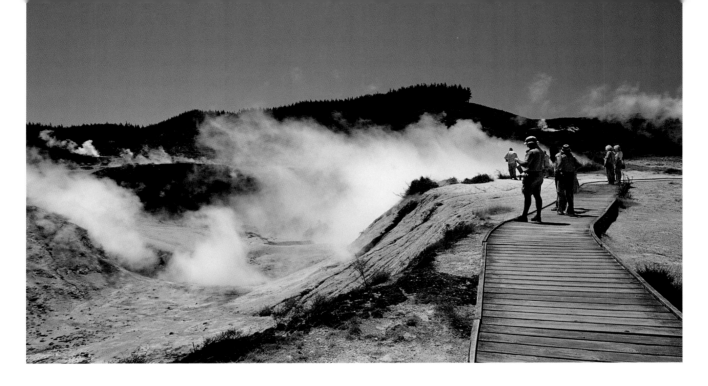

LEFT: In the centre of the North Island, majestic volcanoes dominate Tongariro National Park. The youngest is Ngauruhoe (on right) rising 2290 metres behind the low cone of Pukekaikore, with the peak of Tongariro beyond at left. Ngauruhoe began life as a new vent on the eroded southern flanks of Mt Tongariro and is still active, sporadically erupting ash and lava.

ABOVE: Plate collision is responsible for the volcanoes of the central North Island and the region's ubiquitous thermal activity, visible at sites such as Craters of the Moon, near the city of Taupo. The hot springs and steam vents here gushed with new vigour in the 1950s after the nearby Wairakei Geothermal Power affected underground water levels and pressure.

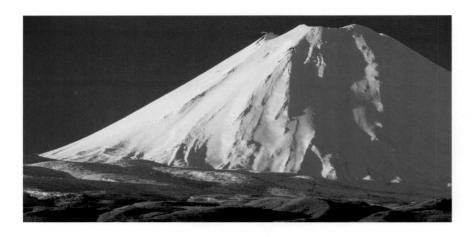

TOP LEFT AND RIGHT: According to Maori myth, when the Polynesian explorer Ngatoro-i-rangi climbed Mt Ngauruhoe (left), he was caught in a snowstorm. He called to gods in his tropical homeland to warm him. They sent underground fire that burst to the surface at places in the Bay of Plenty's volcanic plateau, ending in the mountains around him.

Mythology also accounts for the isolation of Mt Taranaki/Egmont (right). Taranaki once lived with the other mountains in the centre of the island. They were all male except the lovely Pihanga, for whose attention they battled, hurling fire at each other. Tongariro was the victor and the defeated mountains were banished. Taranaki fled 150 kilometres to the west, where it now forms a stunning backdrop to the city of New Plymouth.

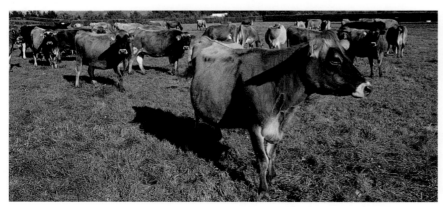

LEFT: Taranaki's fertile land supports a large dairying industry.

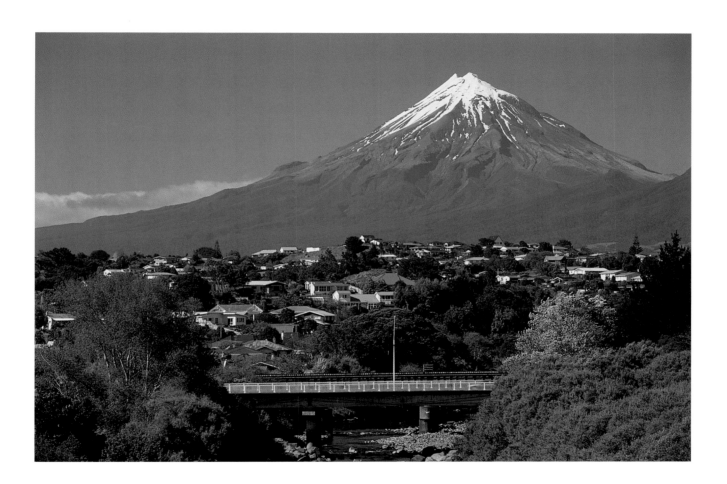

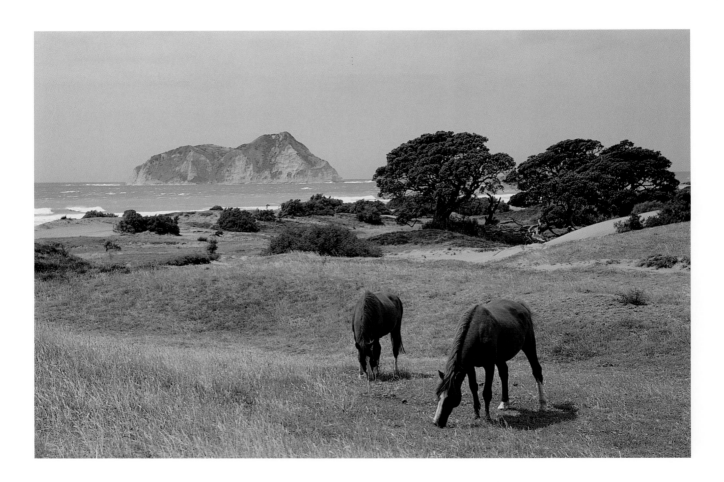

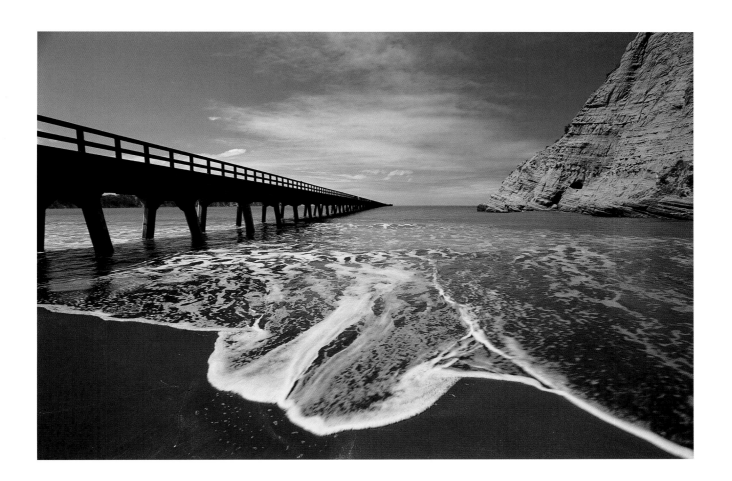

PREVIOUS PAGES: *(p. 22)* Leaving the Bay of Plenty, the coast road winds around the isolated East Cape with its small Maori settlements, where horses are still part of everyday life. *(p. 23)* South of East Cape the country's longest wharf extends 660 metres into Tolaga Bay. Meat and wool from the region's farms were shipped from here for 40 years from 1929.

BELOW: The Hawke's Bay region encompasses the large scallop-shaped bay with the city of Napier at its centre, basking in a sunny, warm climate and boasting popular swimming and surfing beaches. The fountain graces its tree-lined Marine Parade, one of New Zealand's premier seaside boulevards.

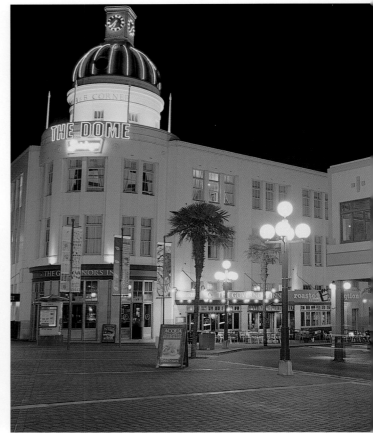

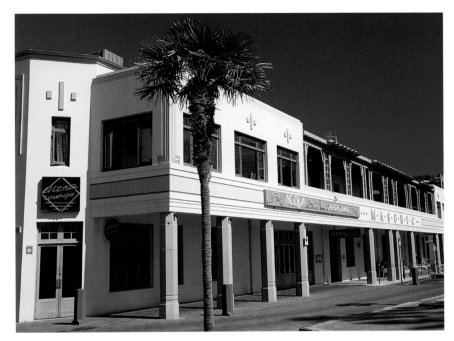

CENTRE AND ABOVE: After an earthquake devastated the city in 1931, leaving hundreds dead, many homes and public buildings were rebuilt in the style fashionable at the time, making Napier the art deco capital of the world. The A&B Building *(centre)* and the Masonic Hotel *(above)* are two fine examples of the streamlined style with chevrons and sunbursts among its varied bold plaster motifs.

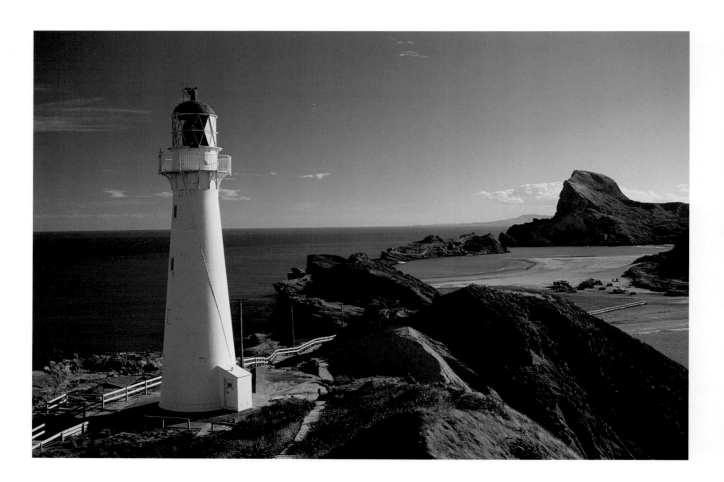

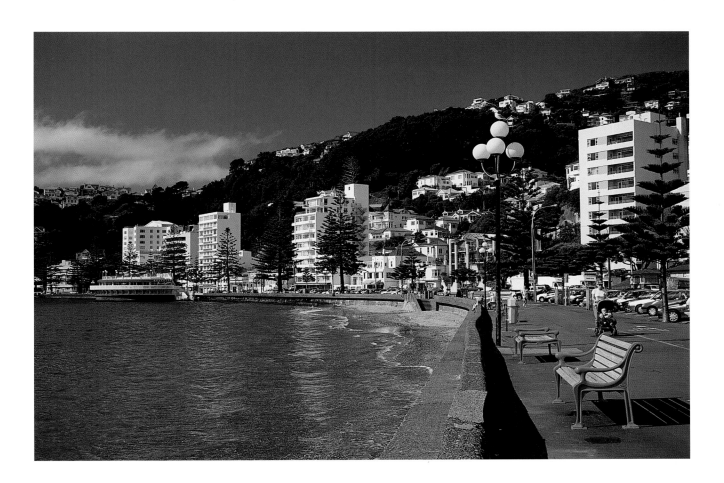

PREVIOUS PAGES: *(p. 26)* The Castlepoint Lighthouse, built in 1913, looks over a popular resort on the Wairarapa coast, south of Hawke's Bay. *(p. 27)* At the bottom of the North Island, the capital city of Wellington is crowded into steep hills around a beautiful deep-water harbour. Just a few minutes from the city centre, pretty Oriental Bay is a sought-after suburb with its promenade, beach and boat harbour.

BELOW: Since 1902 a cable car has carried passengers to the hillside suburb of Kelburn and the city's university.

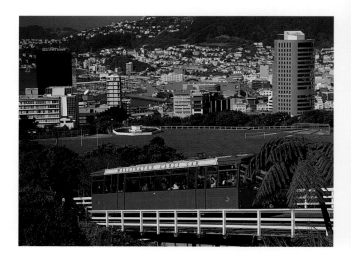

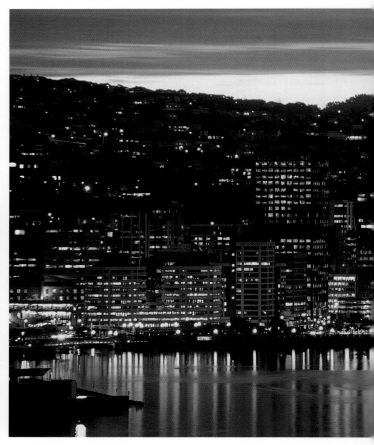

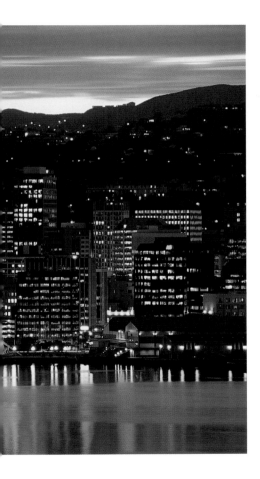

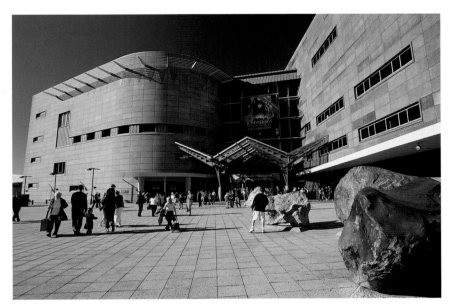

ABOVE: Wellington is the country's political heart, home to Parliament, and also to the new Museum of New Zealand, Te Papa Tongarewa, housed in an impressive building on the harbourfront. The city has a vibrant arts scene, with the biennial International Festival of the Arts a major attraction.

LEFT: On a fine day, and when freezing gales aren't blowing in from Cook Strait, the 'Windy City' is a magical place. Seen from Mount Victoria, on calm, clear nights the city is a sea of lights from harbour to hillsides.

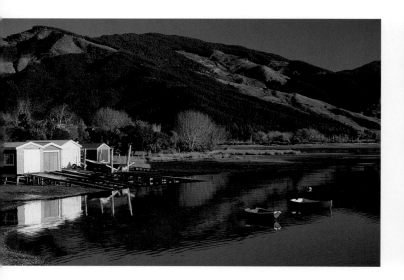
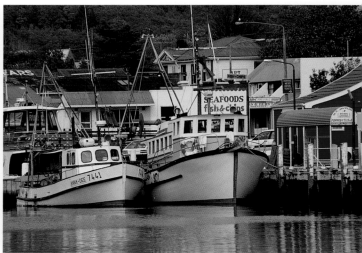

ABOVE LEFT AND CENTRE: Marlborough and Nelson in the northern regions of the South Island are blessed with stunning scenery: the numerous idyllic waterways of the sounds, snow-capped mountains, golden beaches, three national parks, forest, lakes, vineyards and pleasant towns. Queen Charlotte Sound (*left*) is the largest of the labyrinthine sounds and the sea passage for all shipping connecting Wellington to the port at Picton (*centre*) at the head of the sound.

RIGHT: The dry hills of the upper Wairau Valley lead down to the plains. Farmland on the Wairau Plains has been reclaimed from swamps. It has traditionally been used for sheep and cattle grazing and increasingly for horticulture, including apples, olives and cherries. Viticulture, though, has made it famous; it is home to some of the great names of New Zealand wine.

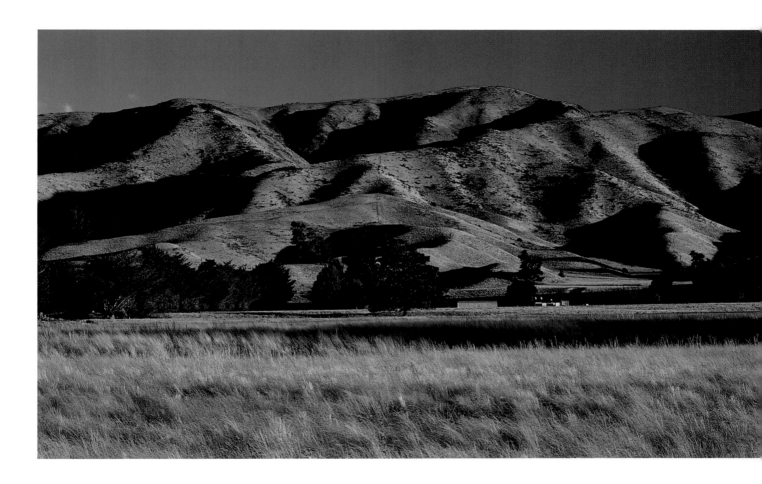

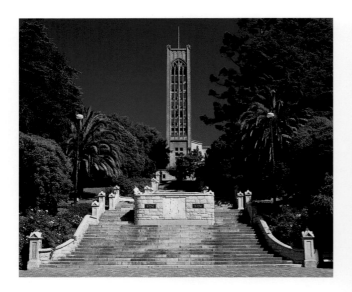

ABOVE: Nelson, the largest and oldest city in the north of the South Island, is an energetic place with a lively arts and crafts community and a keen sense of history. Nelsonians are proud of their many fine historic buildings, such as the city's traditional symbol, the art deco cathedral, begun in 1925 and, after much debate and delay, finally consecrated in 1972.

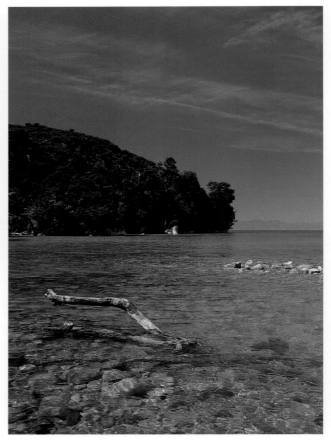

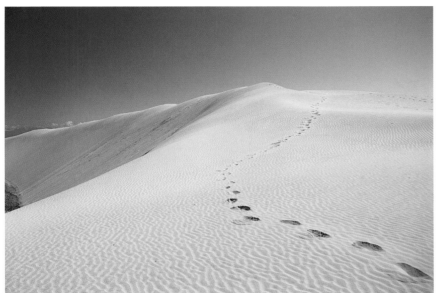

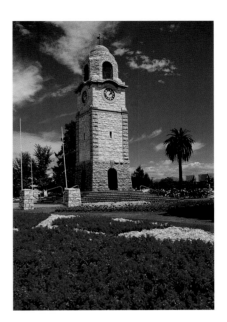

ABOVE: On the northwestern tip of the South Island, Farewell Spit is a 26 kilometre-long finger of sand dunes, shell banks and marshland. It is an internationally important wetland and bird sanctuary.

LEFT: Not far from Nelson the Abel Tasman National Park is the country's smallest but best known national park. It stretches along a stunning coastline of sandy, bush-edged beaches such as at Tinline Bay.

ABOVE RIGHT: Blenheim, in the Marlborough region, is famous for its annual Food and Wine Festival, and as the heart of the wine district. The town, with its many fine historic buildings, is built around the clock tower and gardens of Seymour Square.

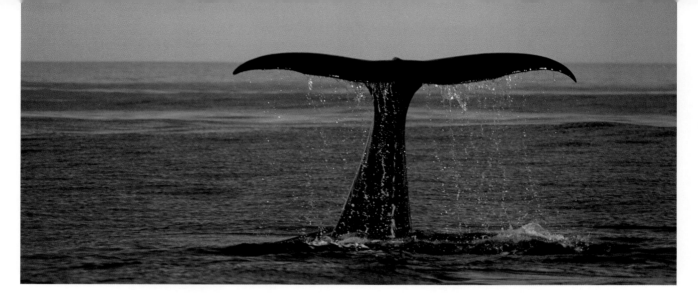

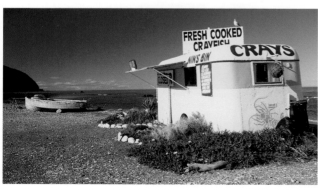

ABOVE: A sperm whale dives off Kaikoura, on the east coast south of Marlborough. Traditionally a village devoted to fishing, tourism is now its mainstay, with internationally renowned marine mammal-watching tours. Often encountered are fur seals, orca, and minke, humpback, pilot and sperm whales.

LEFT: Kaikoura means 'meal of crayfish', and the region's delicacy is readily available from cafés, restaurants and popular roadside stalls.

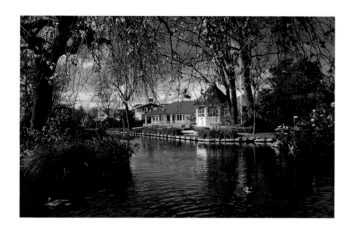

Christchurch is the South Island's largest city, and the country's most English, with a number of beautiful parks and leafy garden suburbs, through which the Avon River meanders *(left)*. The Antigua Boatsheds *(below)* are the starting point for leisurely trips down the Avon by canoe, paddle boat, row boat or punt.

Restored green and cream trams do an inner-city loop taking in some of the city's shopping areas and attractions, such as the beautiful Gothic-style Arts Centre building *(below left)*, once part of the city's university, now housing an arts, crafts and entertainment complex as well as cafés and restaurants.

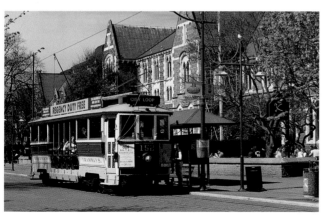

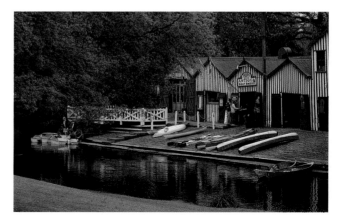

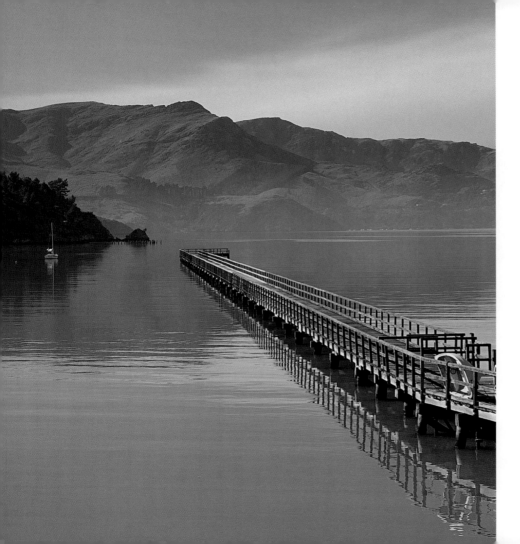

LEFT: Christchurch's sea port of Lyttelton Harbour is reached via a rail tunnel, built in 1867, and a recently completed road tunnel under the Port Hills. Boat cruises are the most popular way of exploring the harbour's many tranquil bays such as the serene Governor's Bay.

RIGHT: From Christchurch the great expanse of the Canterbury Plains sweep inland to the foothills of the Southern Alps, such as at Broken River (*pictured*). Sheep farming was the main enterprise of early British settlers and is still an essential part of the region's culture and economy.

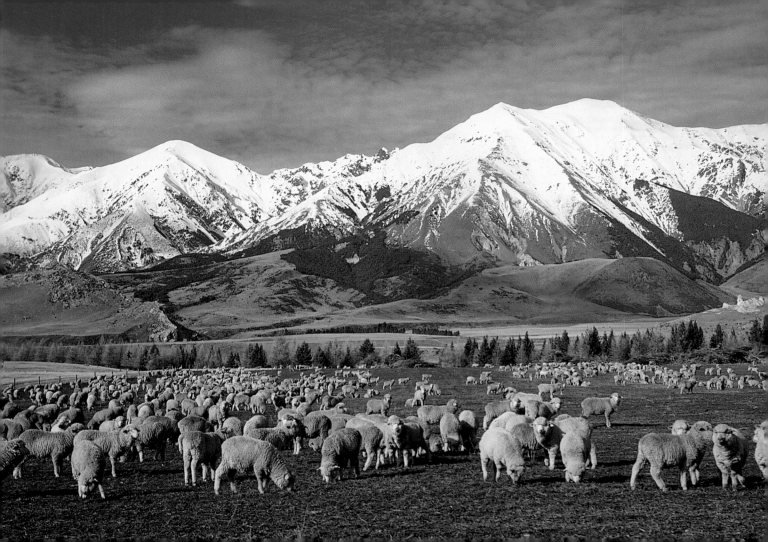

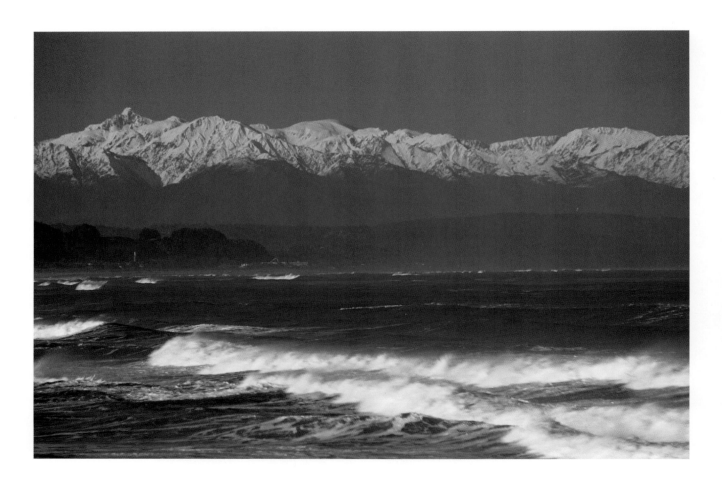

OPPOSITE: The West Coast of the South Island runs 600 kilometres along the rugged and dramatic Tasman Sea coastline. Remote, pristine and spectacularly scenic, the coast features wild rocky beaches and bush clad hills that sweep up to the peaks of the Southern Alps, seen here near Greymouth.

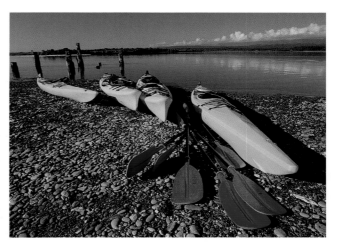

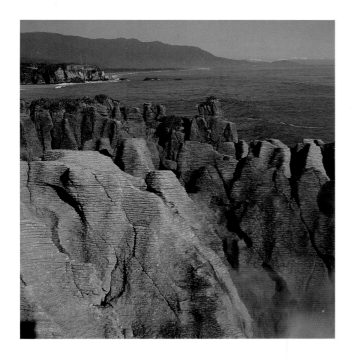

ABOVE: Kayaks are the ideal way to explore the extensive lagoon and tidal flats at Okarito, the country's largest unmodified wetland. The lagoon is a nesting site for around 100 rare and beautiful kotuku, or white heron.

LEFT: On the coast at Punakaiki, in the Paparoa National Park, columns of spray thunder through blowholes in the 'pancake' layers of stratified limestone.

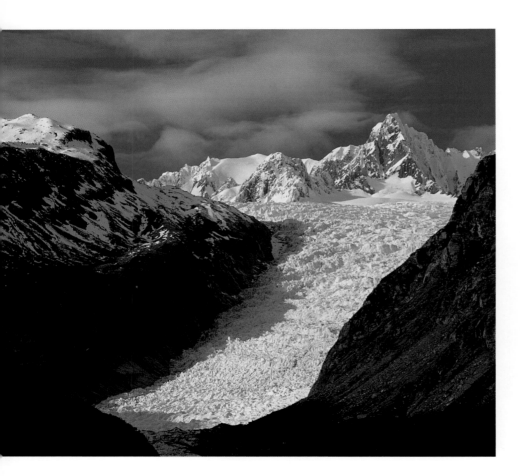

LEFT: Franz Josef Glacier (*pictured*) and Fox Glacier are the most famous and easily accessible of over 60 glaciers in the Westland/ Tai Poutini National Park. The mighty rivers of ice flow down from the Southern Alps to within 20 kilometres of the Tasman Sea. They travel much faster than other similar glaciers due to the amount of snowfall feeding them and their steep angle of descent.

RIGHT: Lake Matheson near Fox Glacier township in Westland National Park perfectly reflects the forest that fringes it, along with the stunning panorama of the Southern Alps peaks of Aoraki/Mt Cook and Mt Tasman. The lake fills a depression created thousands of years ago by the retreating Fox Glacier, which once reached to the sea's edge.

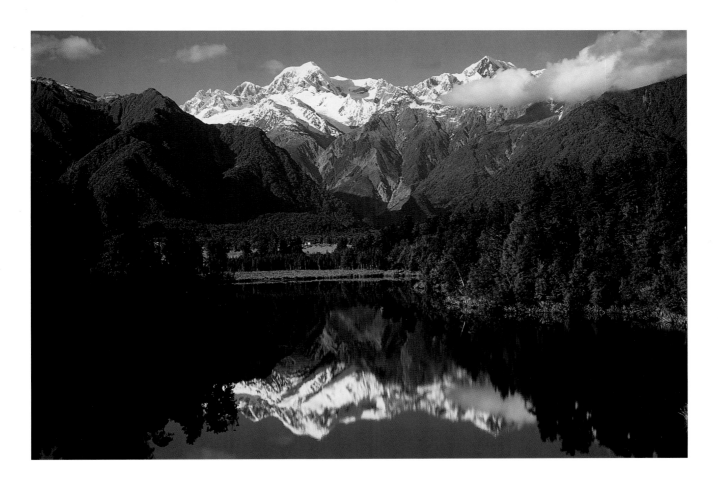

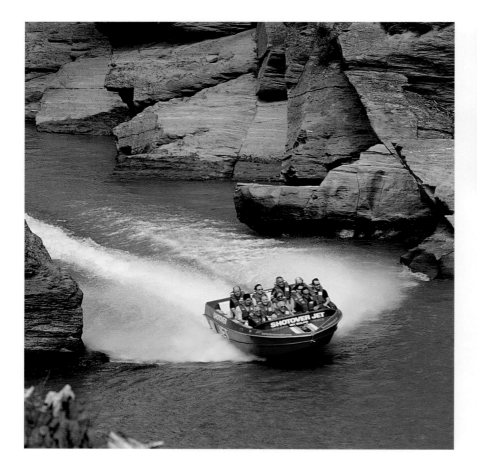

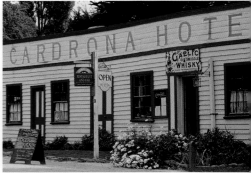

ABOVE: The Cardrona Hotel in the Cardrona Valley captures the romance of the 19th-century Otago goldfields.

LEFT AND RIGHT: In Central Otago, Queenstown is set in a stunning alpine location on the shores of Lake Wakatipu. New Zealand's most famous adventure playground offers everything from bungy jumping to jet boating on the Shotover River *(left)* or more leisurely cruises aboard the stately steamer *Earnslaw (right)*.

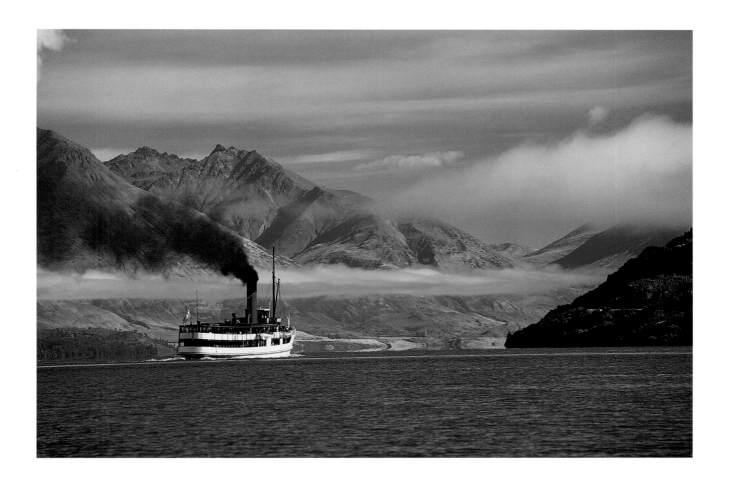

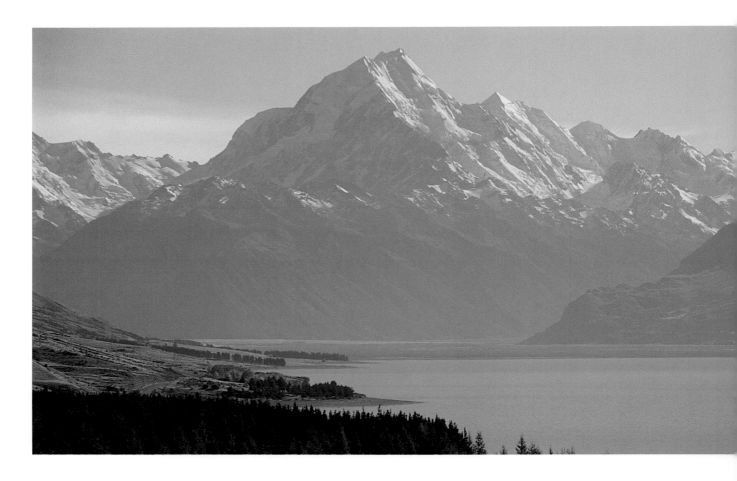

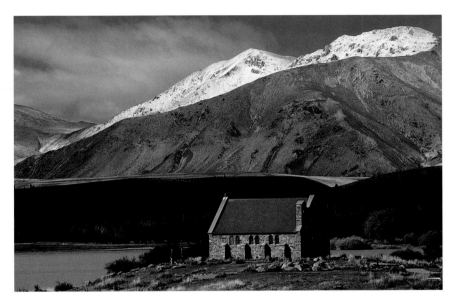

ABOVE: The Church of the Good Shepherd, sitting on the shores of Lake Tekapo with the snow-capped Two Thumb Range beyond it, has one of the most picturesque alpine settings in the country.

LEFT: New Zealand's highest mountain, Aoraki/Mt Cook rises 3754 metres beyond the head of Lake Pukaki. Snow from the mountain feeds the Tasman Glacier which, together with ice melt from the Hooker River, becomes the Tasman River flowing into the lake.

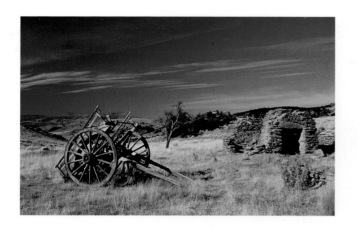

LEFT: The province of Otago and the city of Dunedin came alive with the rush that followed discovery of gold near Lawrence in 1861. Thousands flocked to the goldfields, and quickly moved on when the gold ran out, leaving ruins such as the township at Logan Town near Bendigo *(top left)*. Dunedin's population increased fivefold and its prosperity allowed for ostentatious private homes and magnificent public buildings, such as the Railway Station *(lower left)*, completed in 1906 in Flemish Renaissance style, built of basalt with Oamaru limestone facings, and with an ornate interior.

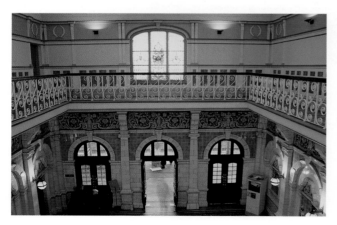

RIGHT: Dunedin sits at the head of the long, sheltered Otago Harbour with the Pacific Ocean beyond. The beach at the seaside suburb of St Clair is a favourite haunt of surfers. Other sea creatures sharing the water and rocky coast around Dunedin include yellow-eyed and blue penguins, albatrosses, seals and sea lions.

NEXT PAGE: Occupying almost the entire southwestern corner of the country, Fiordland National Park in the Te Wahi Pounamu World Heritage Area is an untouched wilderness of forest, fiords and granite peaks, including the majestic Mitre Peak in Milford Sound.

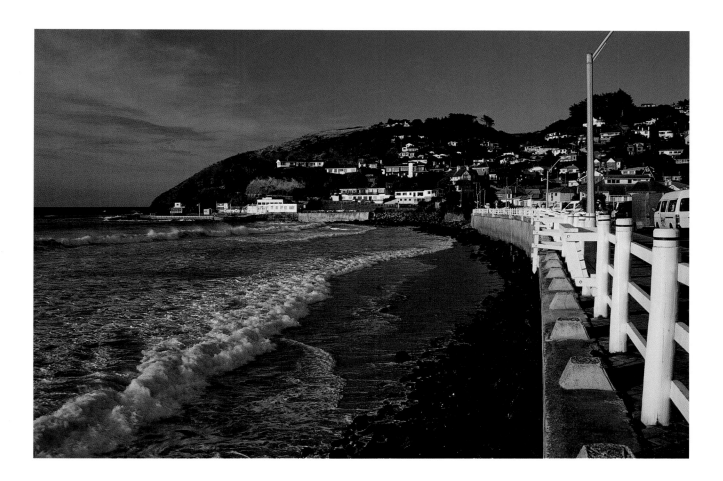

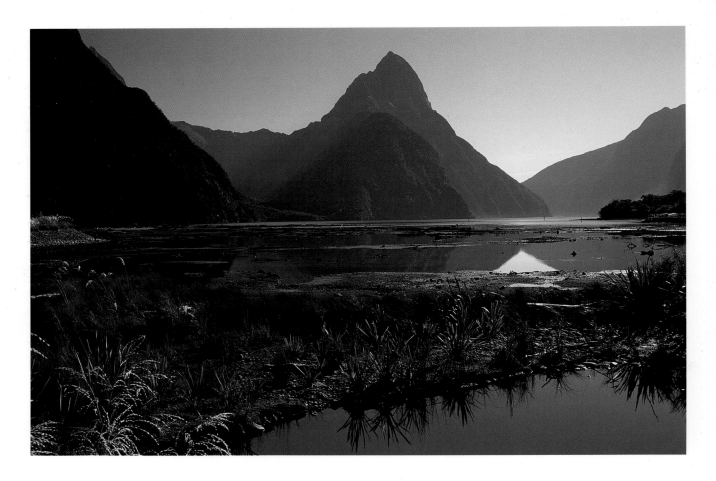